Lancaster County: A Keepsake

A Keepsake

LANCASTER COUNTY

Don Shenk

SCHIFFER
PUBLISHING

4880 Lower Valley Road • Atglen, PA 19310

Published by Schiffer Publishing, Ltd.
4880 Lower Valley Road
Atglen, PA 19310
Phone: (610) 593-1777; Fax: (610) 593-2002
E-mail: Info@schifferbooks.com
Web: www.schifferbooks.com

For our complete selection of fine books on this and related
subjects, please visit our website at www.schifferbooks.com.
You may also write for a free catalog.

Schiffer Publishing's titles are available at special discounts
for bulk purchases for sales promotions or premiums.
Special editions, including personalized covers, corporate
imprints, and excerpts, can be created in large quantities for
special needs. For more information, contact the publisher.

We are always looking for people to write books on new and
related subjects. If you have an idea for a book, please
contact us at proposals@schifferbooks.com.

INTRODUCTION

Lancaster County is located in south-central Pennsylvania and has been referred to as "the Garden Spot of America." That is because it has the most fertile nonirrigated soil in the United States and produces nearly 20 percent of the state's agricultural output. Tourism has become a large industry in Lancaster County, much of the interest being the largest, best-known, and most-visited Amish settlement in the world. Other highlights include its covered bridges, the revitalized city of Lancaster, many historical sites, and picturesque farms and small towns located throughout the county.

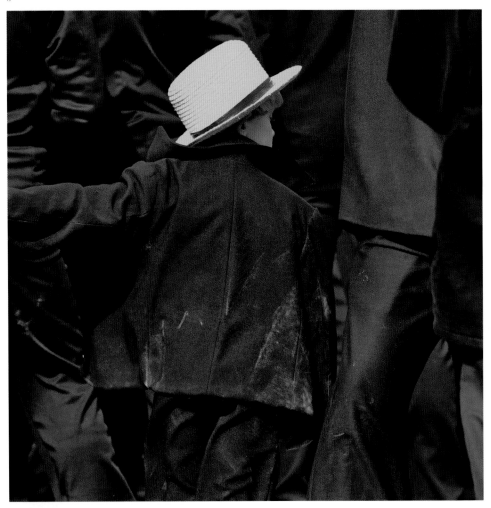

Amish boy at Mud Sale

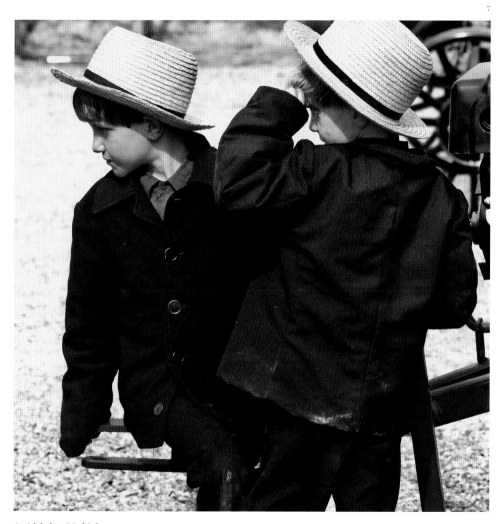

Amish lads at Mud Sale

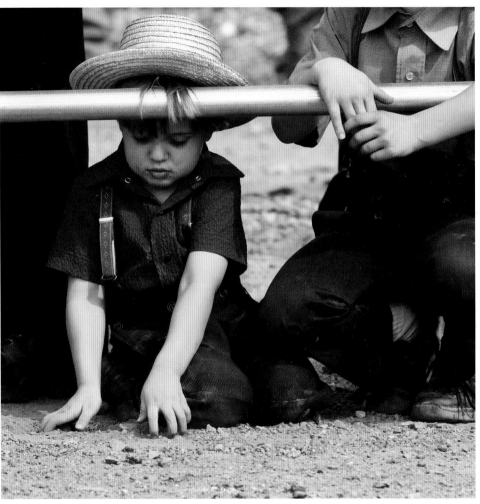

Playing at a horse auction

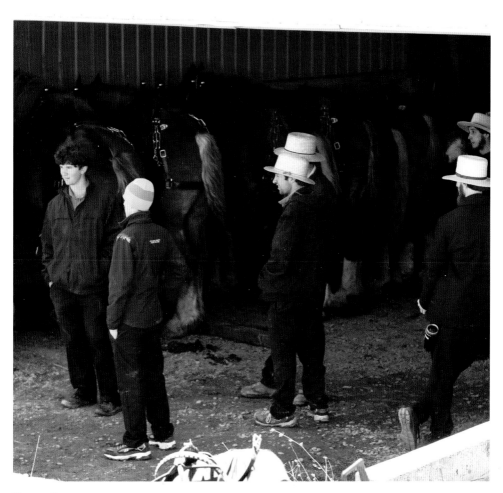

Horse auction

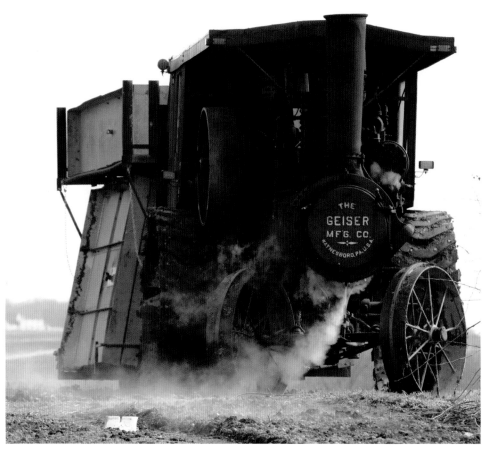

Steam tractor exits field

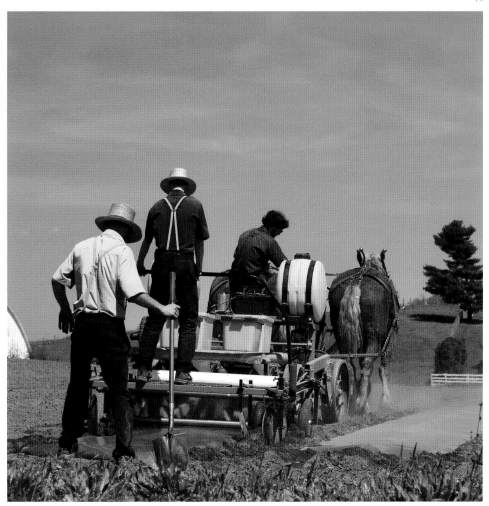

Planting vegetables

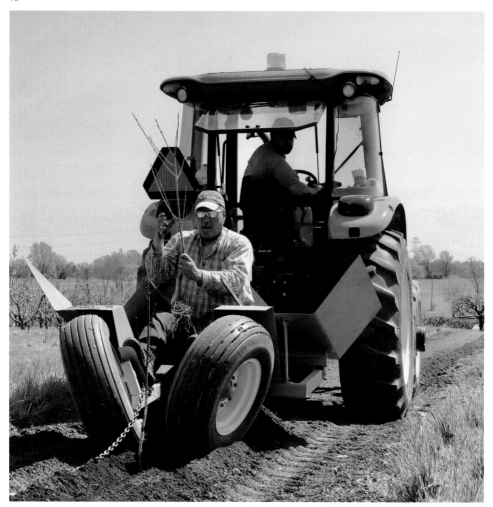

Planting peach trees

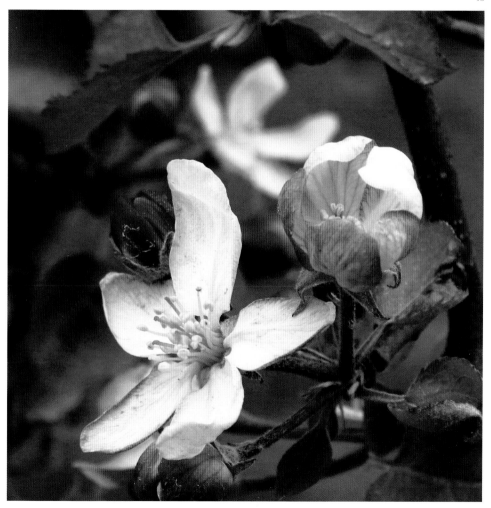

Apple blossoms

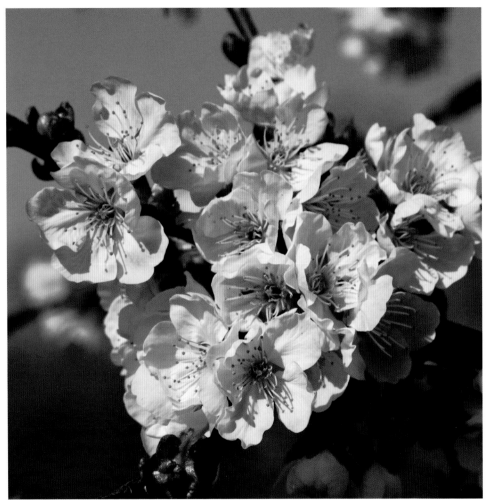

Cherry blossoms

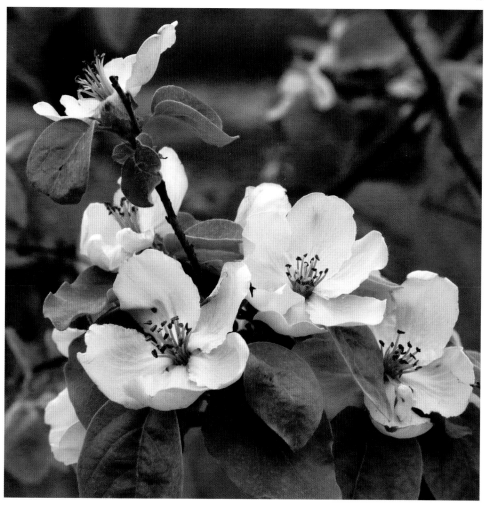

Quince blossoms

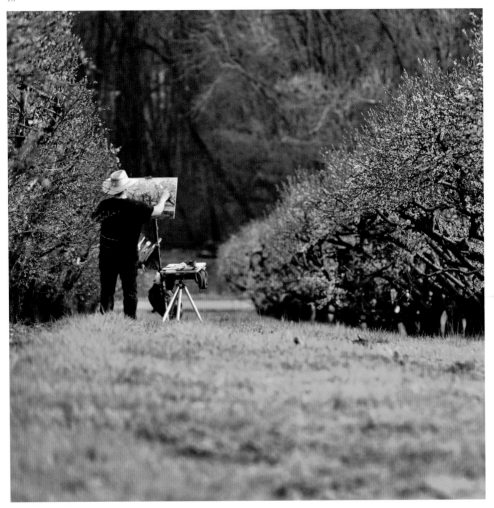

Artist in peach orchard

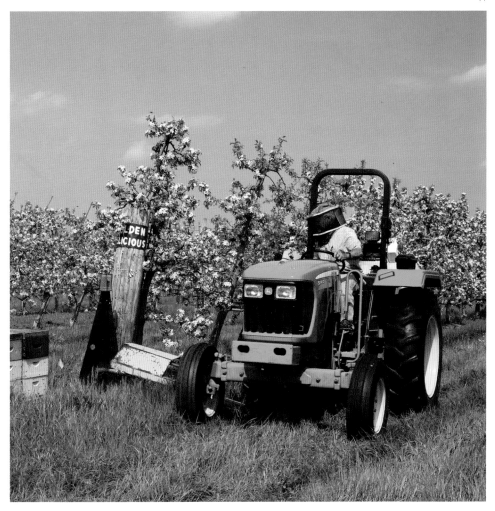

Working in apple orchard

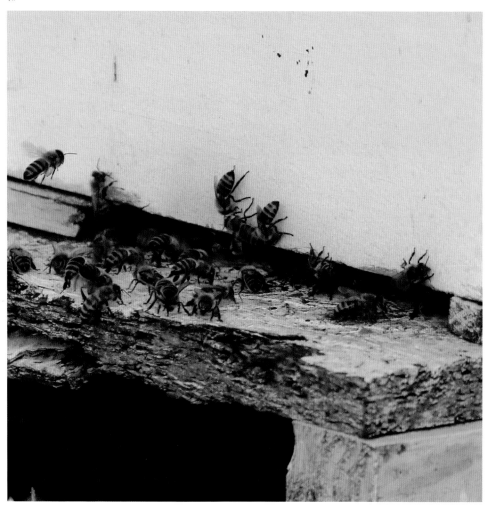

Pollinators in orchard

Purple weed

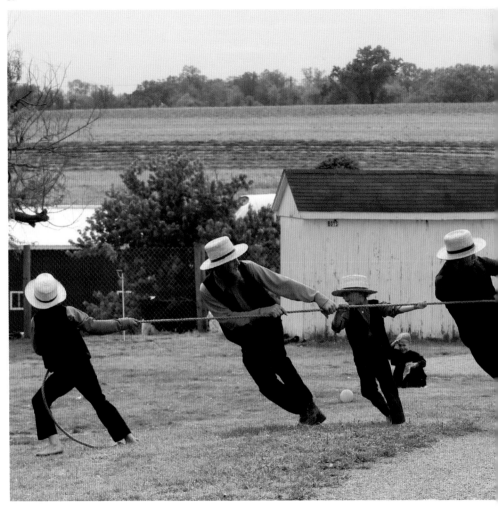

Tug of war

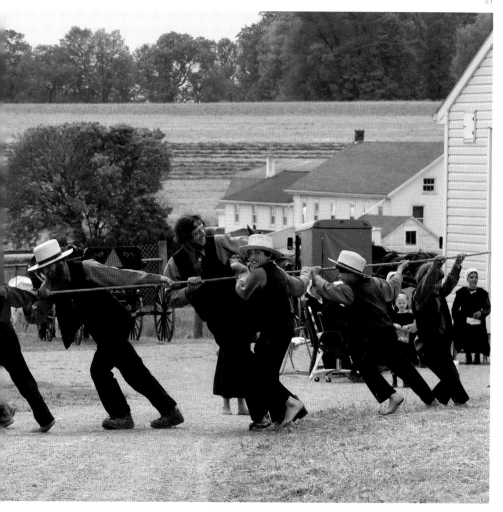

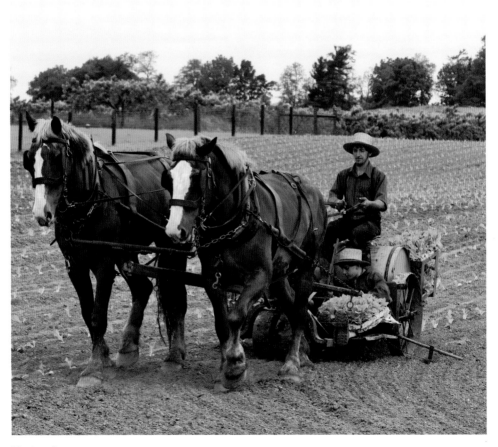

Planting tobacco

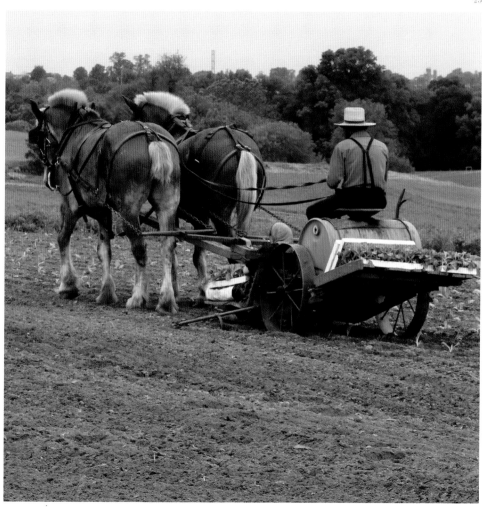

Planting tobacco

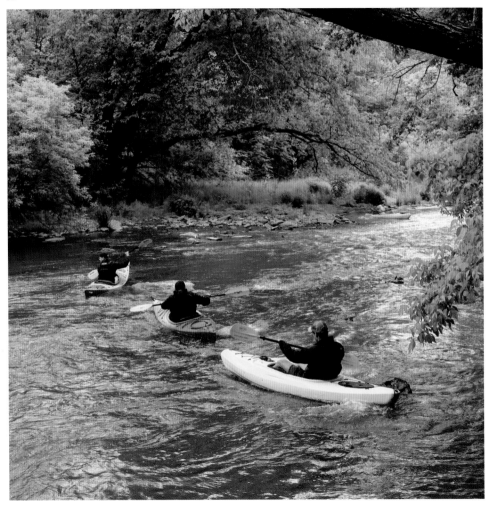

Kayaking on Pequea Creek

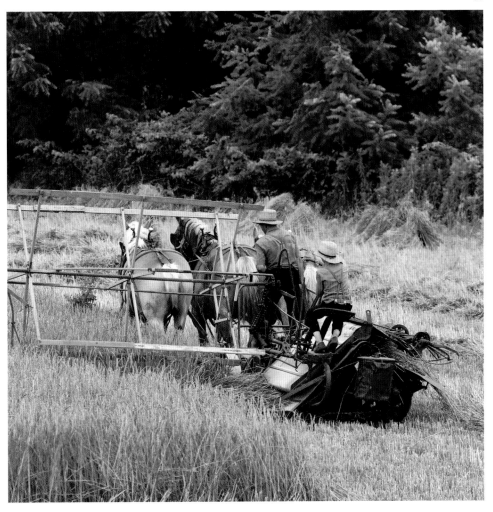

Cutting grain

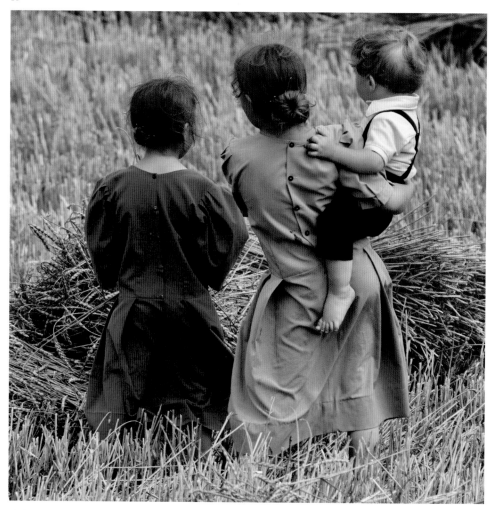

Children in a grain field

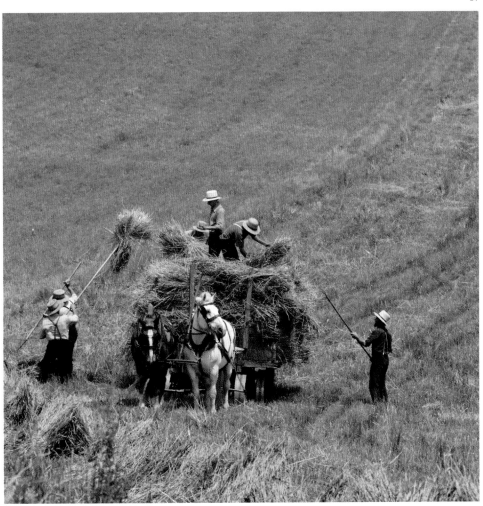

Loading grain

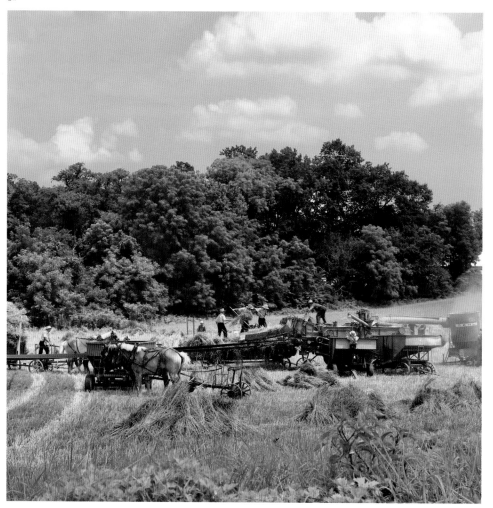

Threshing grain

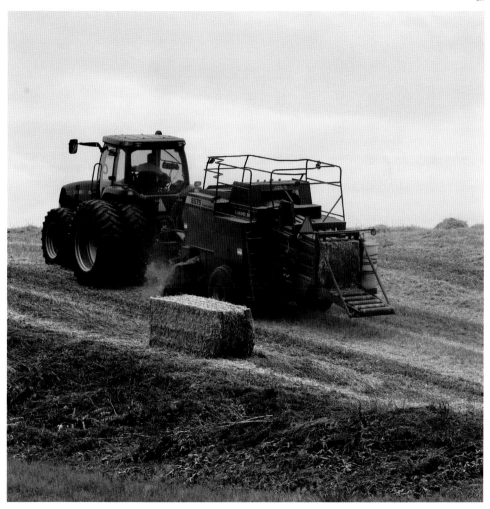

Baling straw

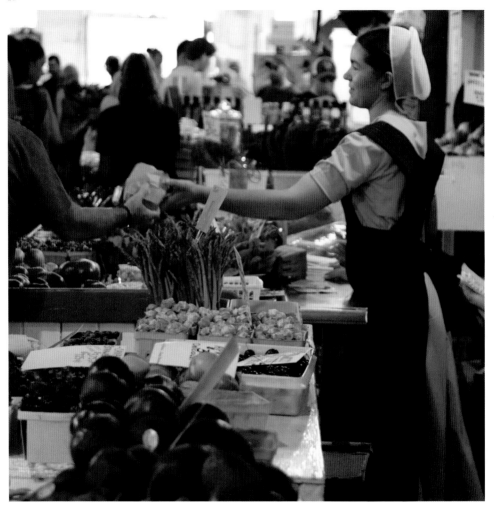

Selling produce at Central Market

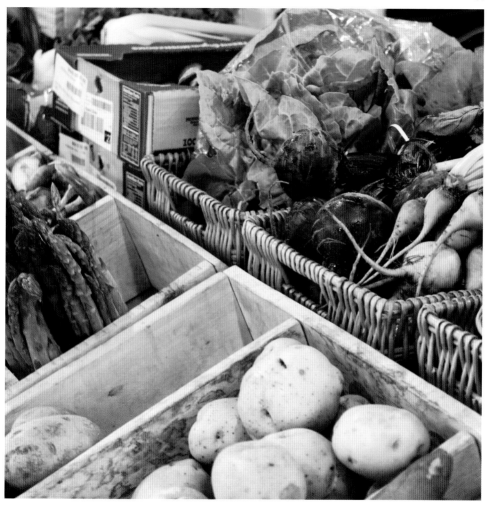

Vegetables at Central Market

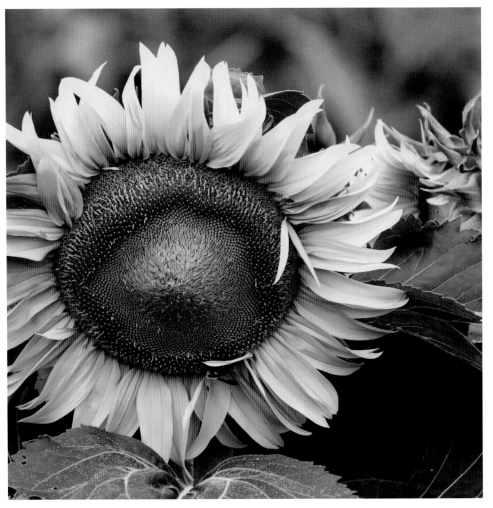

Sunflower

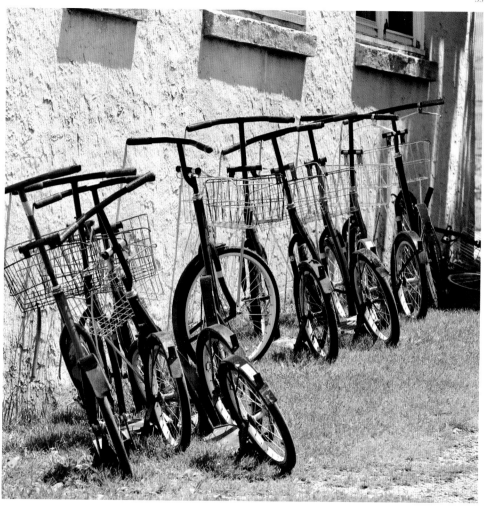

Scooters at an Amish school

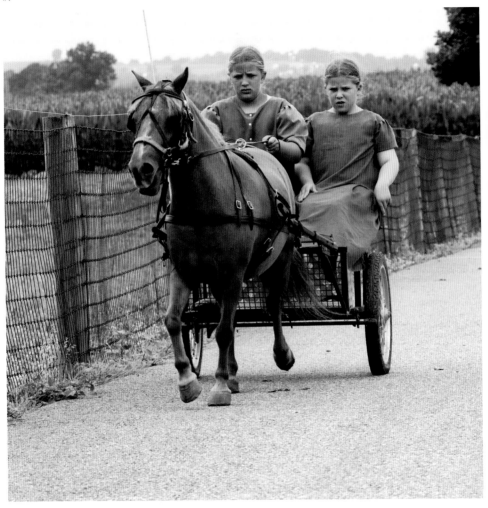

Pony cart ride

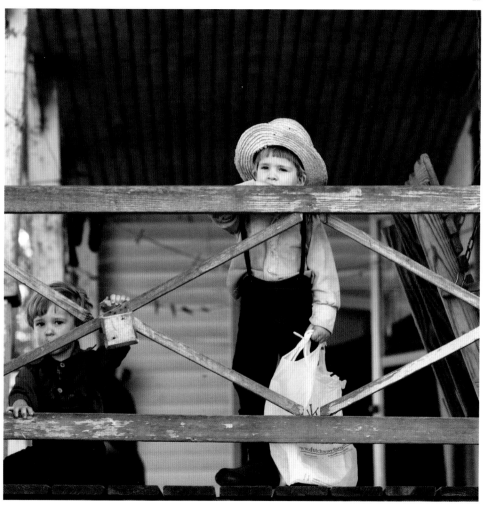

Children peering from porch

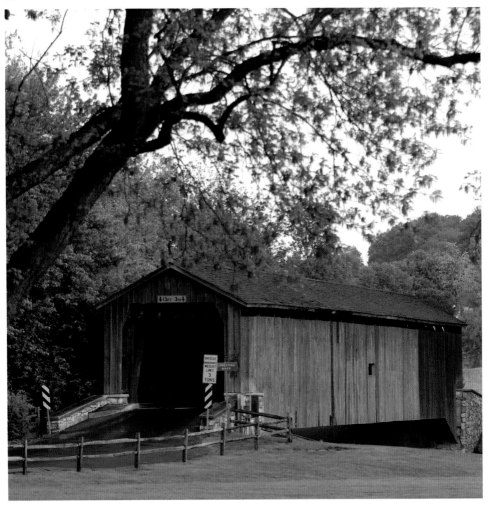

Covered bridge

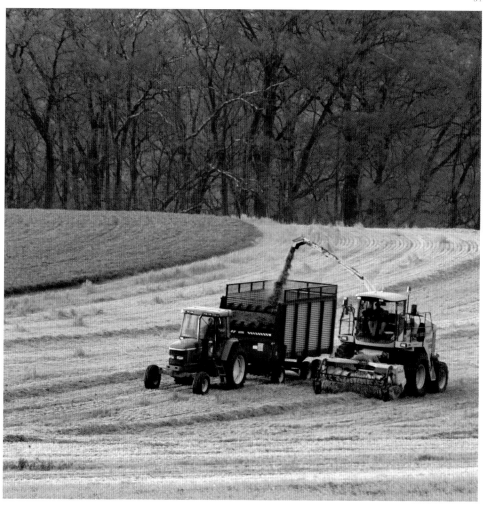

Chopping hay

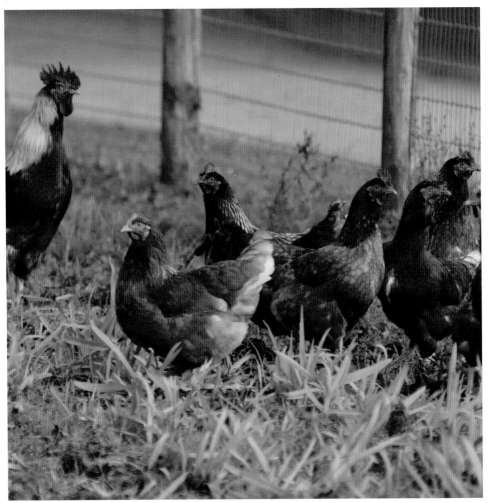

Free-range chickens

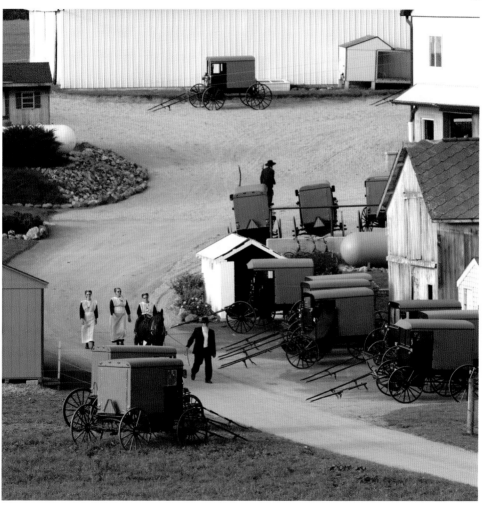

Leaving a church service

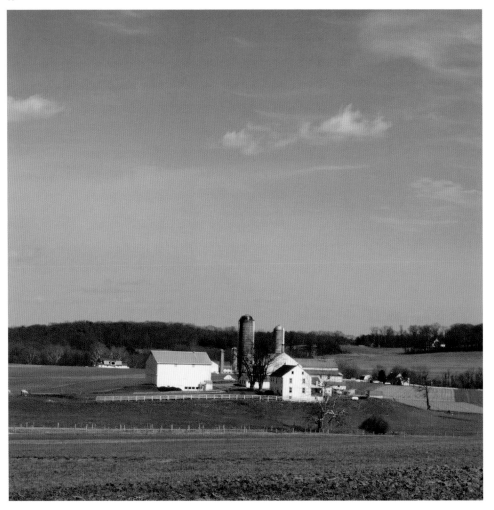

Picturesque farm

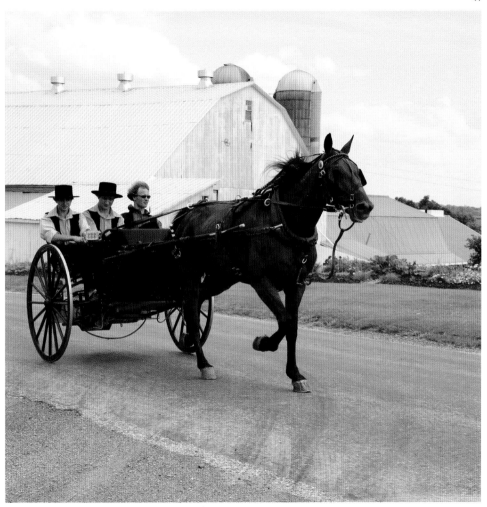

Traveling along a country road

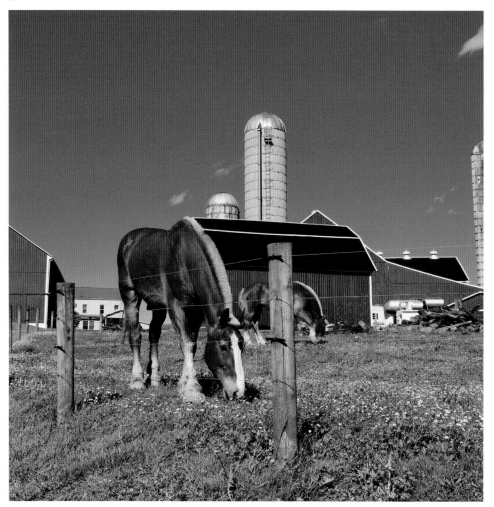

Spring day at the farm

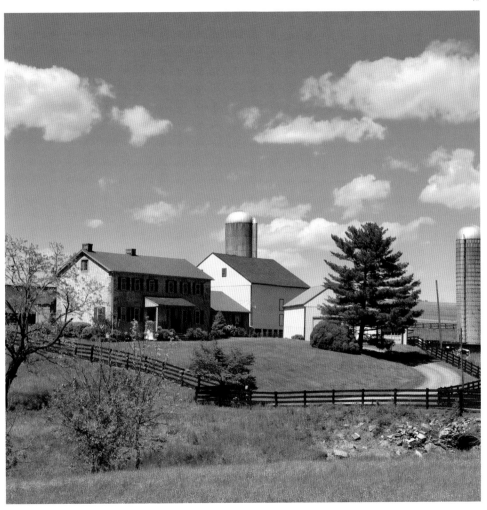

Farm in southern Lancaster County

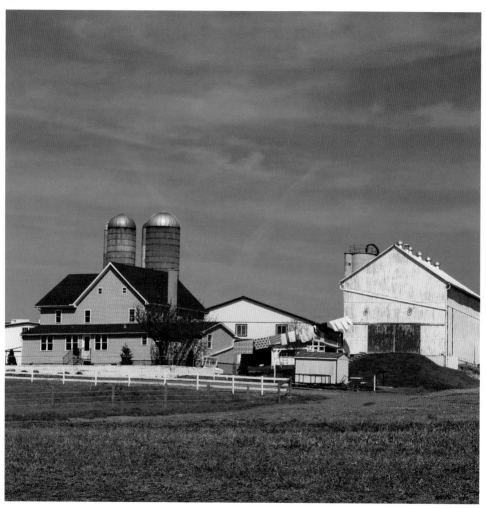

Amish farm

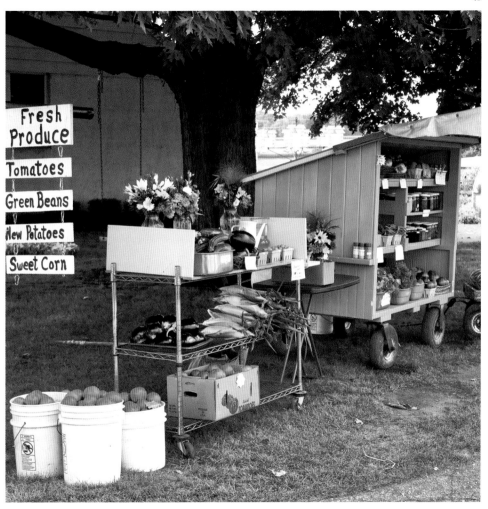

Roadside produce stand

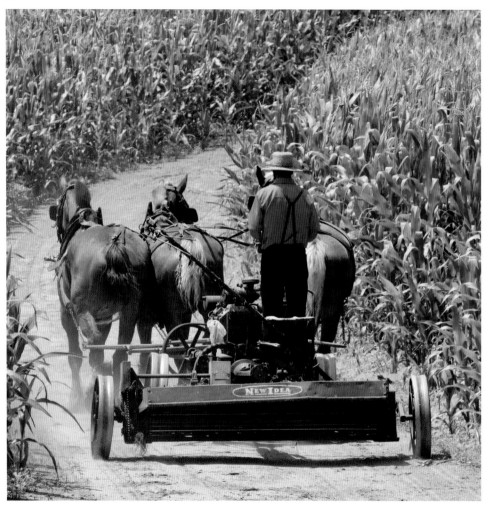

Going to hayfield through cornfield

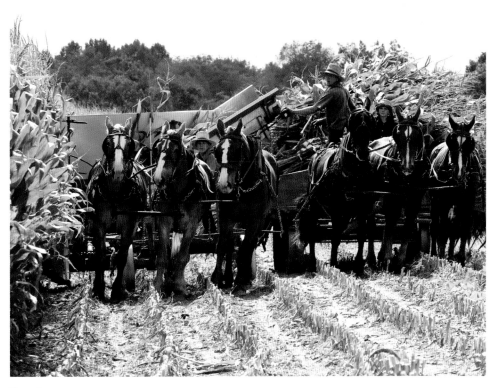

Harvesting corn

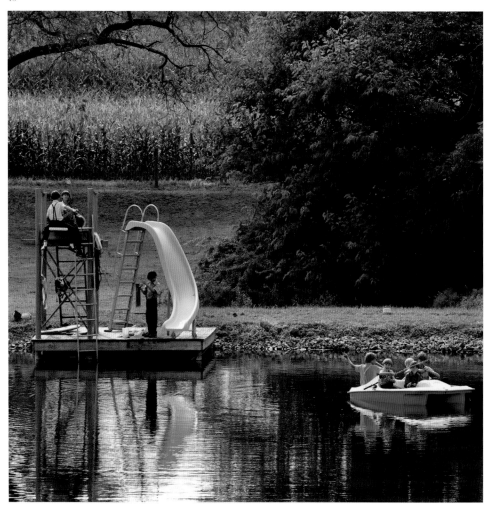

Great day to go fishing

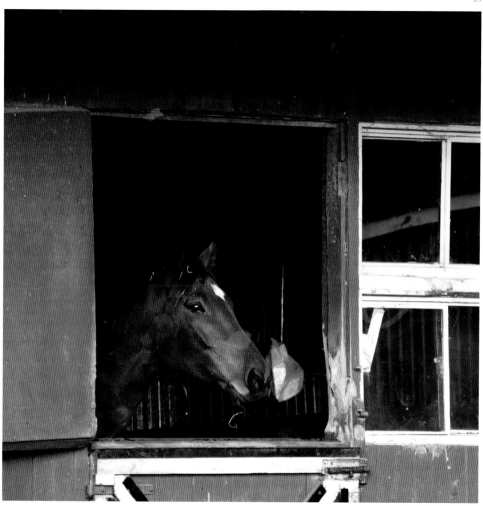

Horse in shed

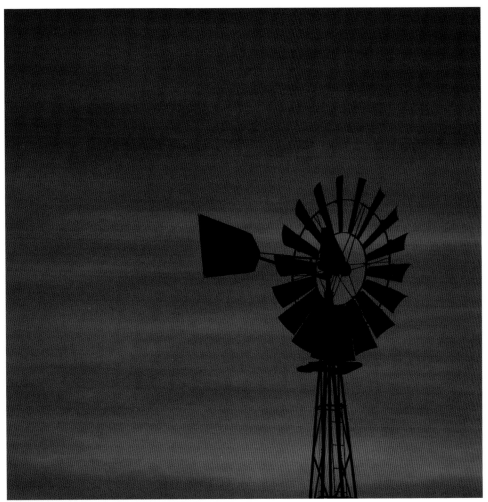

Windmill

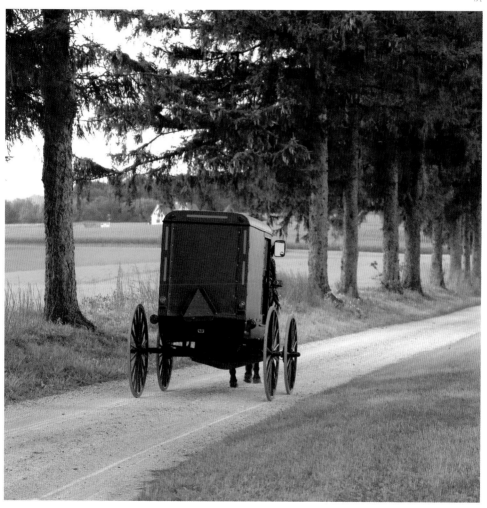

Country lane

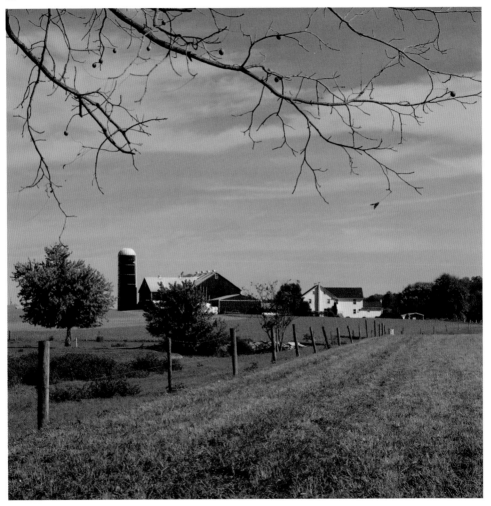

Amish farm

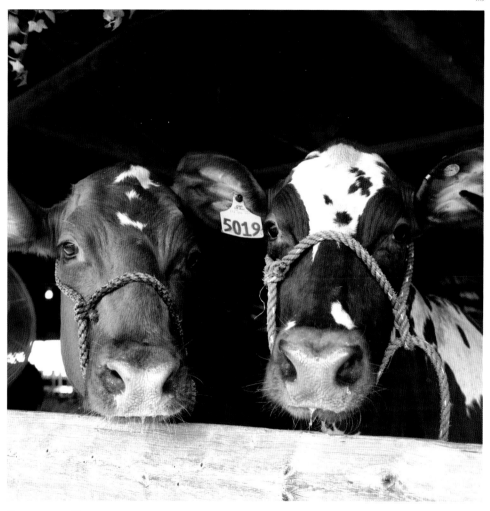

Cows at country fair

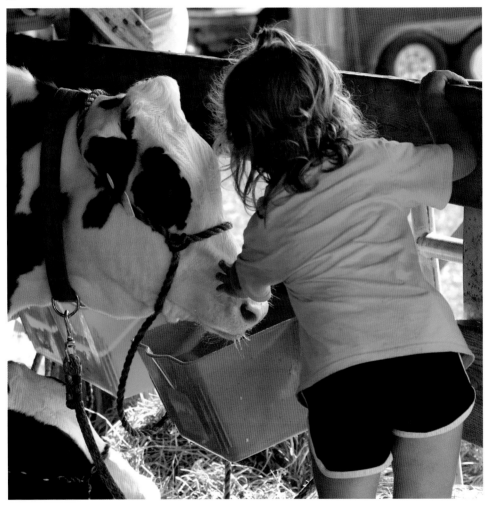

Petting cow at fair

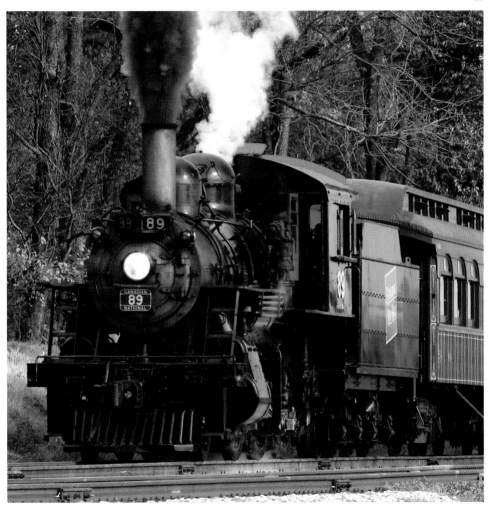

Strasburg Rail Road

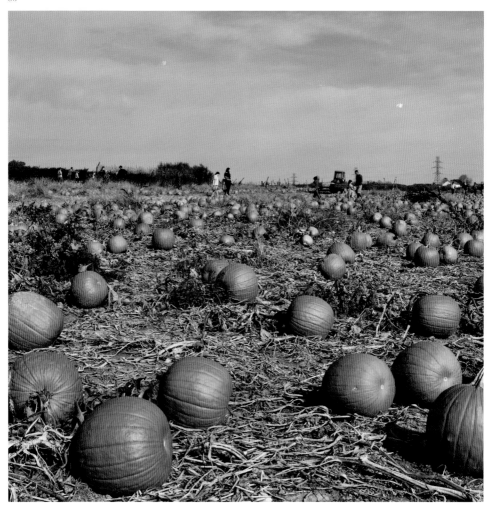

Hayride to pumpkin patch

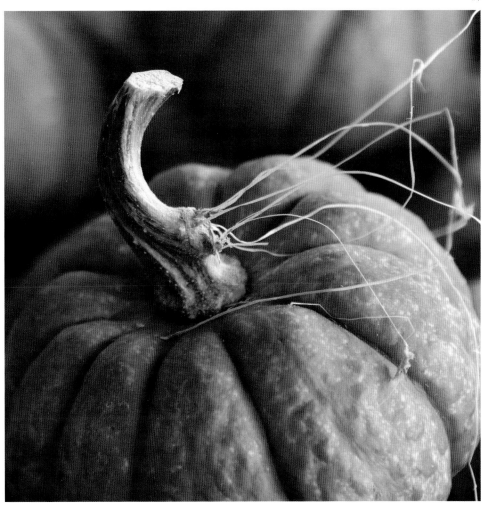

Pumpkins

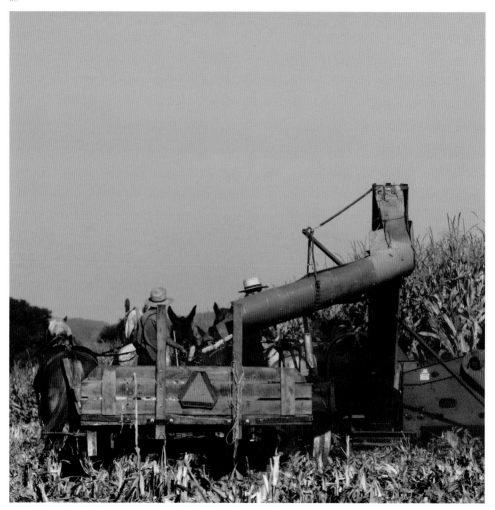

Picking corn

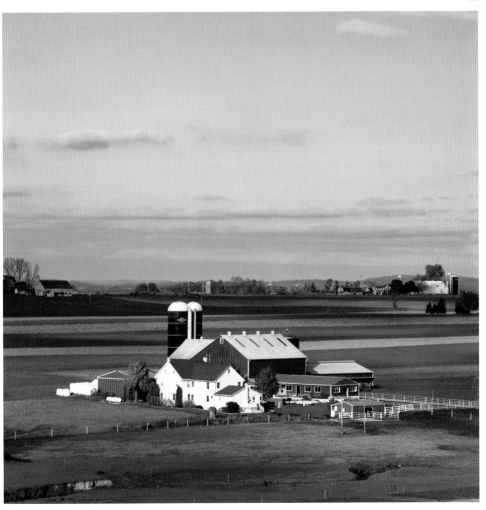

Scenic farms

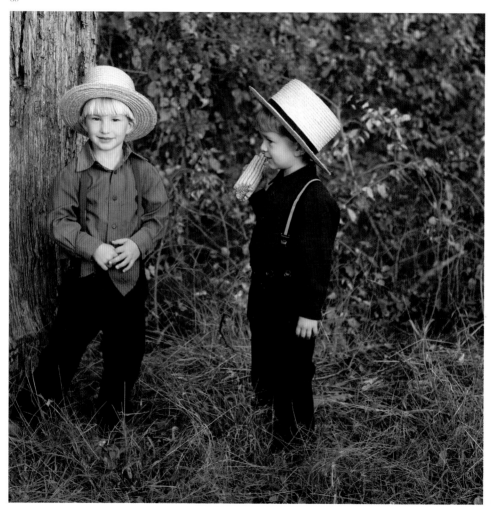

Amish boys with ear of corn

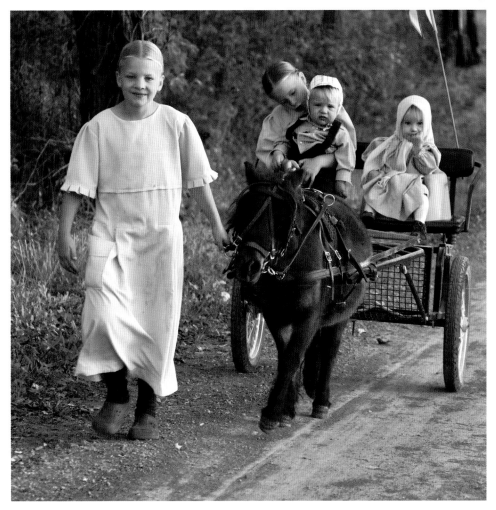

Amish children with pony

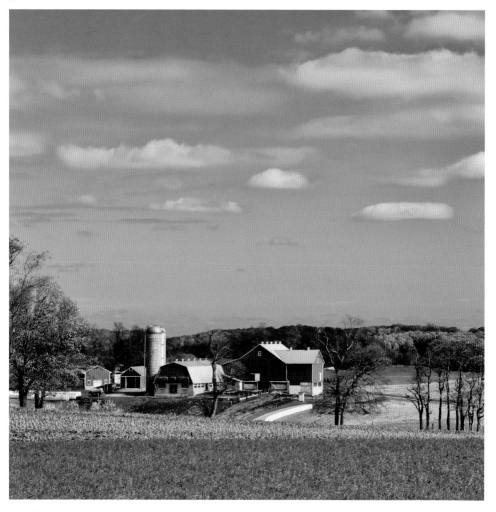

Beautiful farm

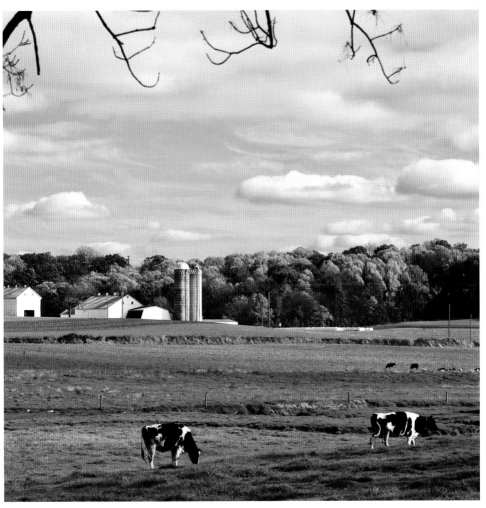

Scenic fall day

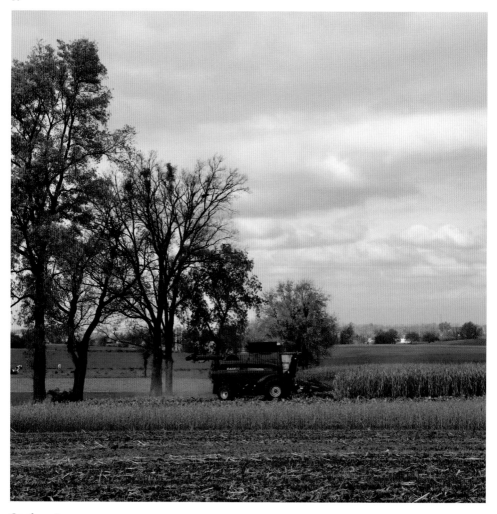

Corn harvest

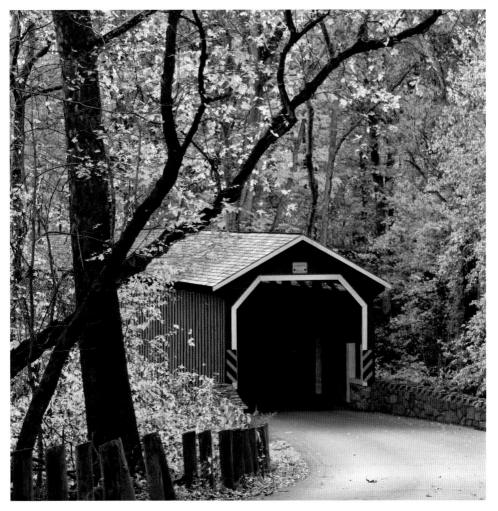

Covered bridge

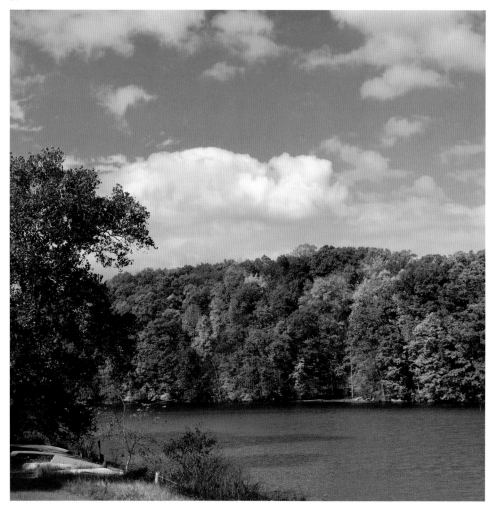

Peaceful fall day

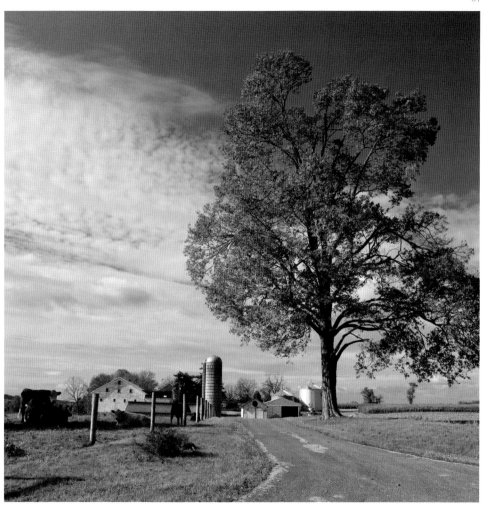

Gorgeous autumn day

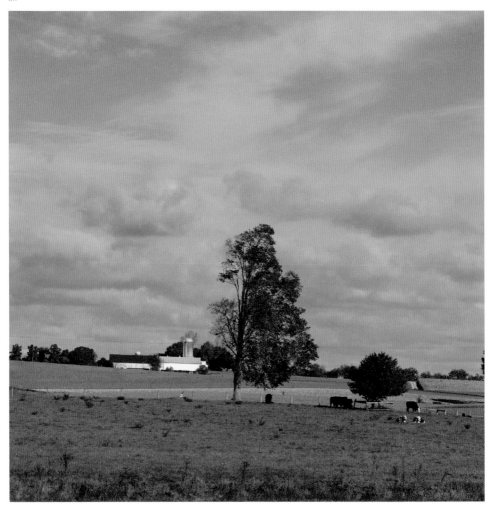

Cows on autumn day

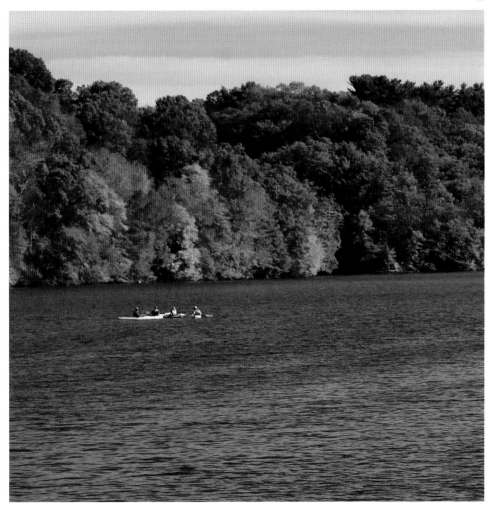

Octoraro Lake

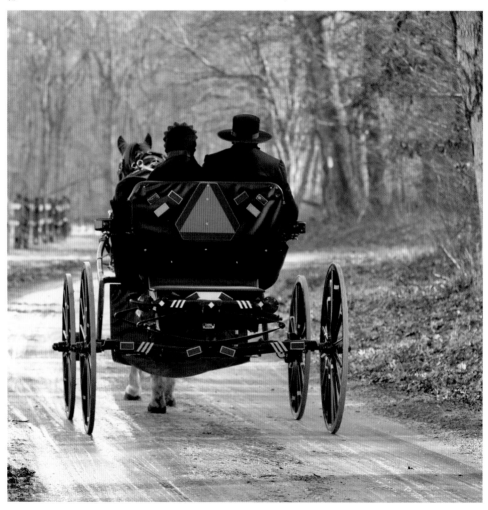

Through the woods

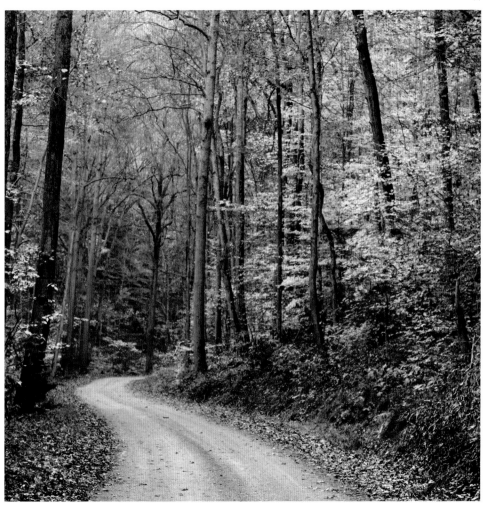

Fishing Creek Nature Preserve

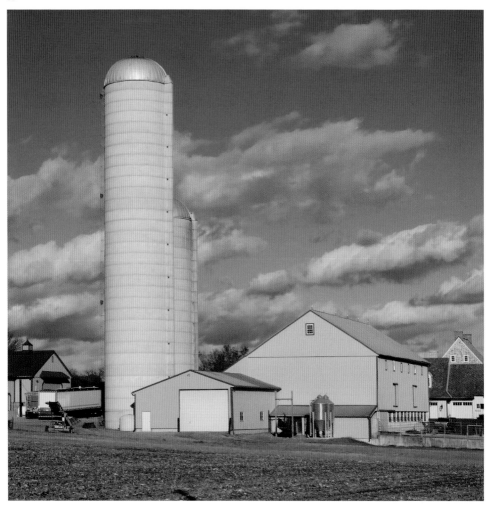

Southern Lancaster County farm in autumn

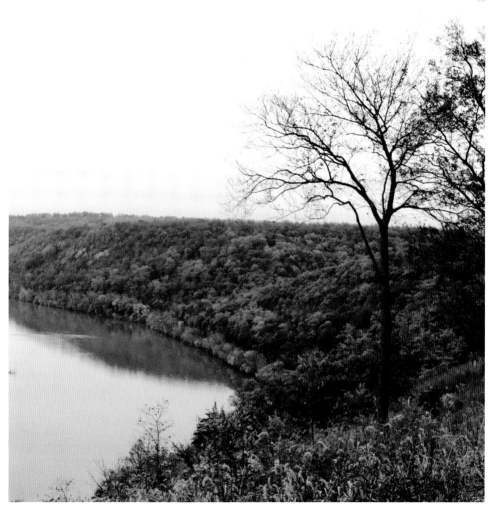

Pinnacle Point

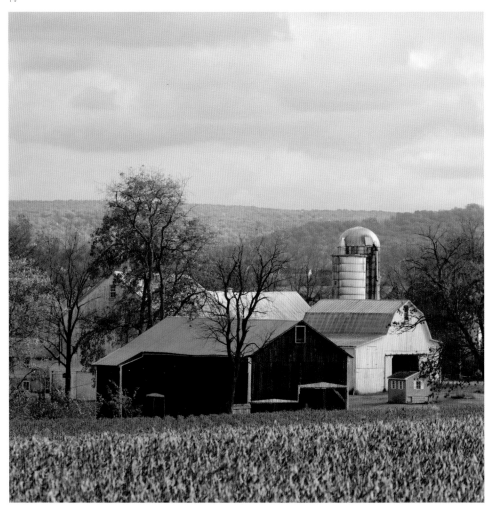

Northeastern Lancaster County farm

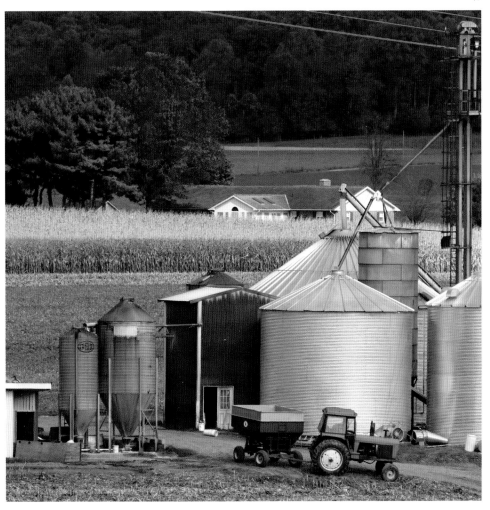

Northern Lancaster County farm

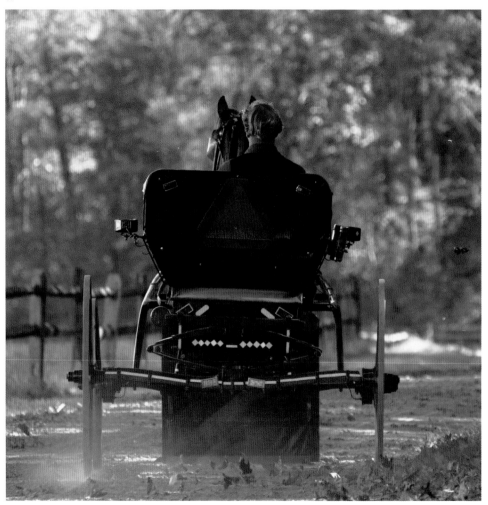

Sunday afternoon ride

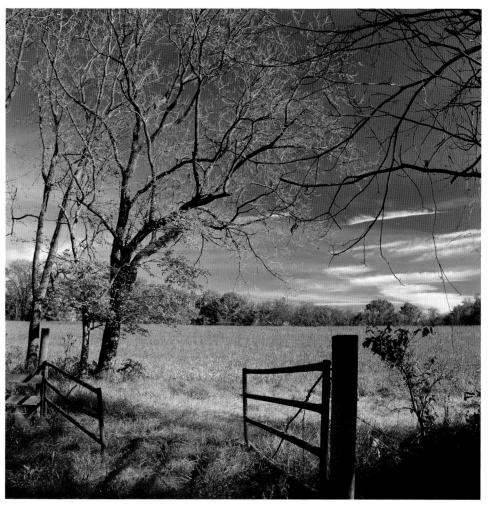

Gorgeous fall day

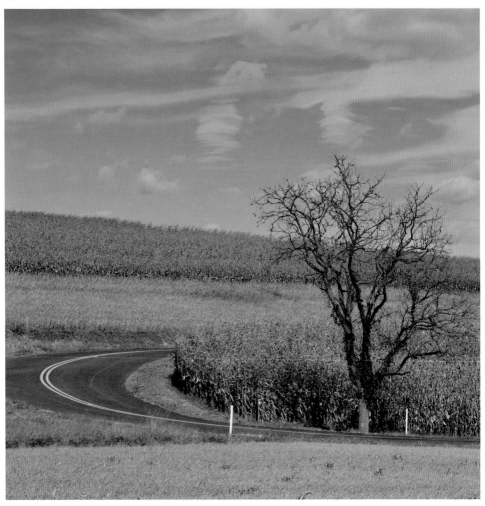

Ready for harvest

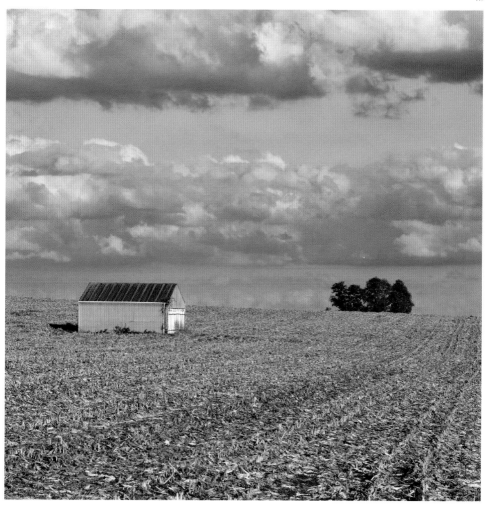

Awe-inspiring fall day

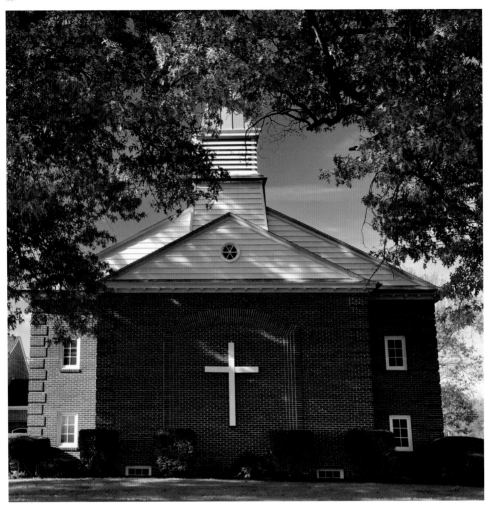

Central Manor Church

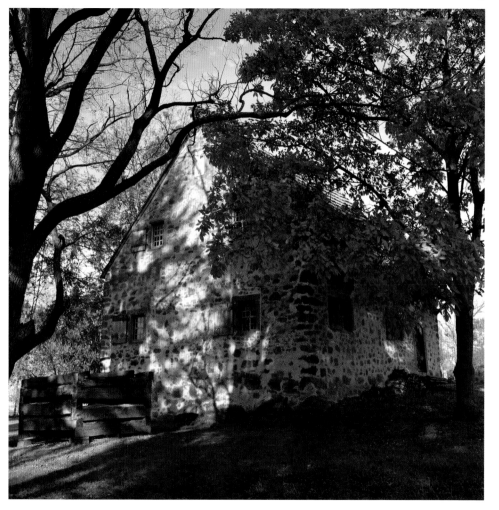

Hans Herr House

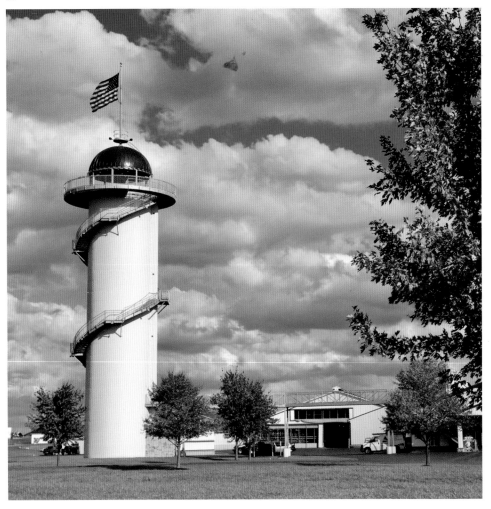

Farm observation silo

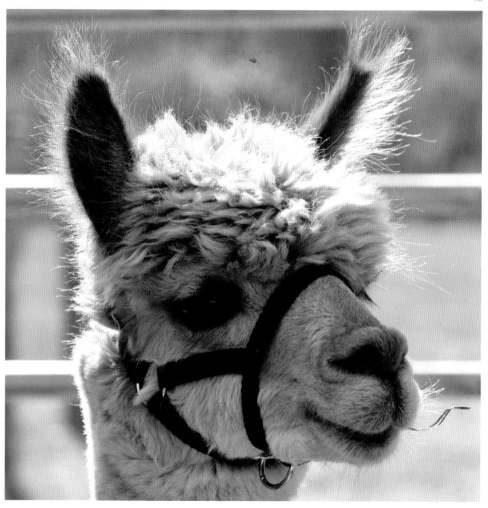

Alpaca

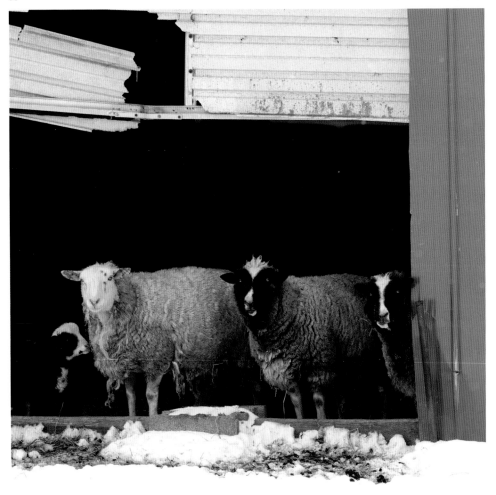

Sheep

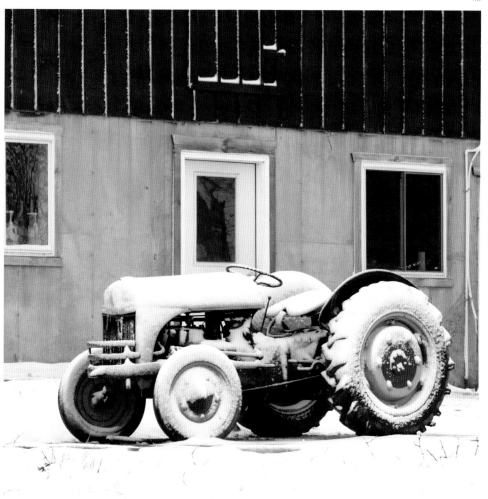

Tractor

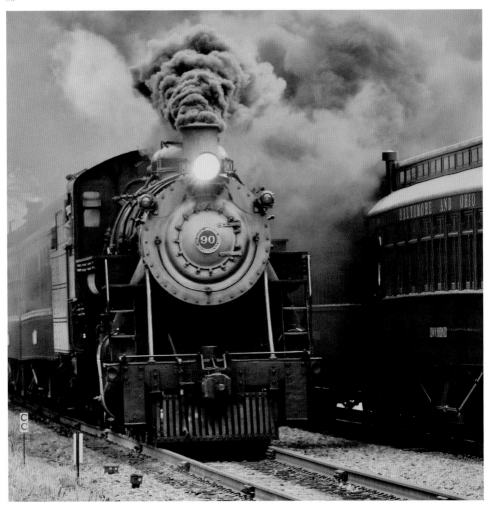

Steam and cinders

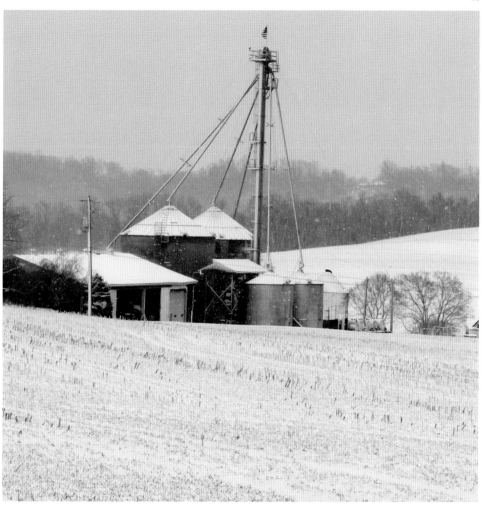

Snowy day

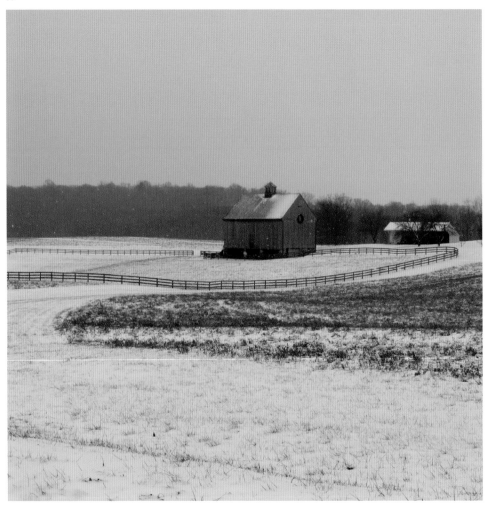

Horse barn

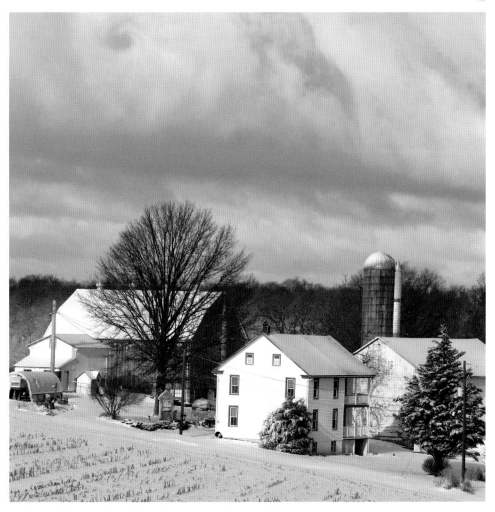

Wonderful winter day

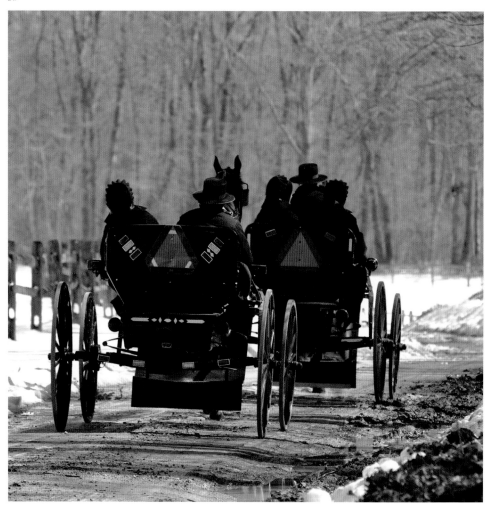

Buggies

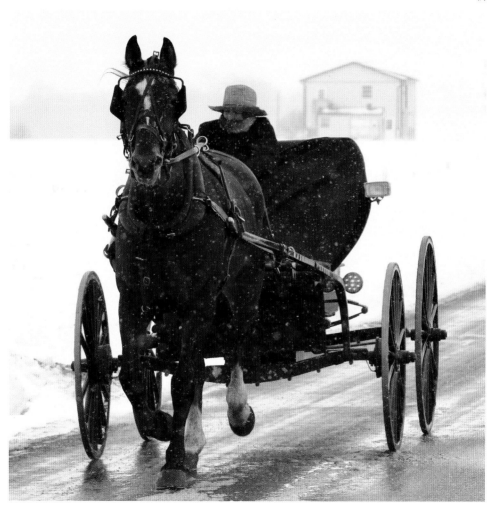

Cold winter day

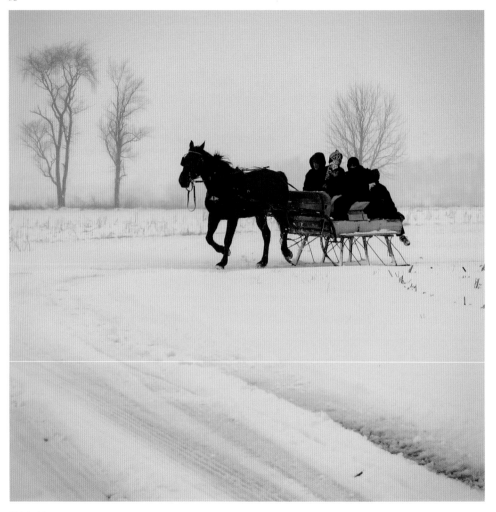

Sleigh ride

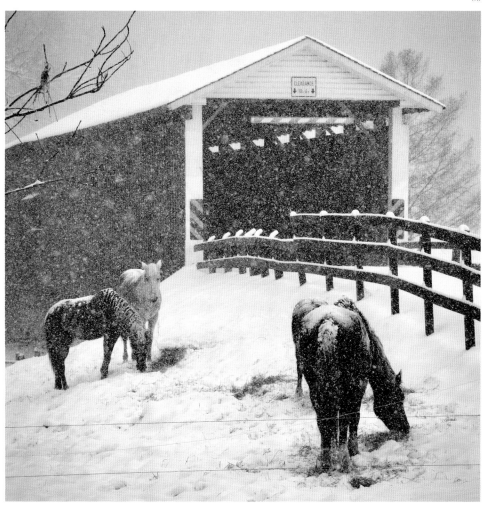

Covered bridge

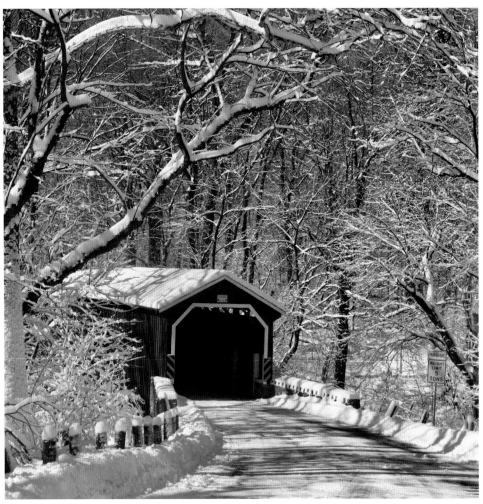

Covered bridge

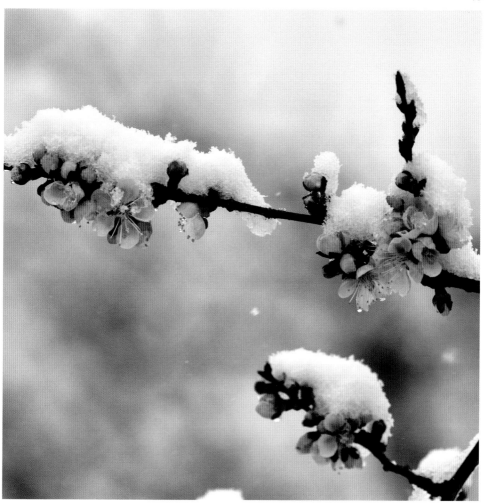

Spring snow

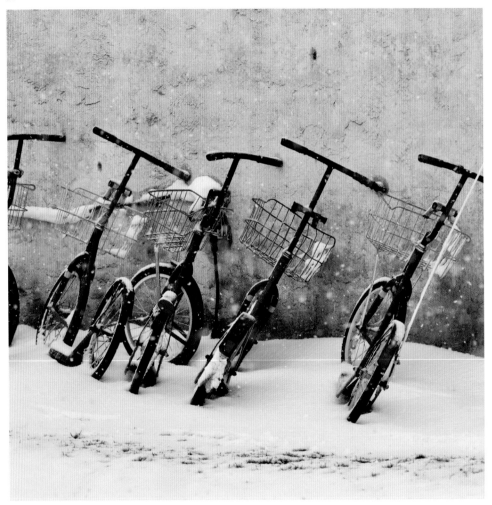

Scooters